LIDLIPS

LIDLIPS
Lessons I Didn't Learn In Photo School

Syl Arena

PixSylated

LIDLIPS Lessons I Didn't Learn In Photo School:
100 Modern Insights On Photography As
Art, Philosophy, Science, Business & Lifestyle

A PIXSYLATED BOOK

First Edition—January 2010

ISBN–13: 978-0-9842253-0-9

ISBN–10: 0-9842253-0-7

Educational Sales: e-mail "Schools@PixSylated.com"

Cover photo—LIDLIPS #6 and #32
"I often fire my camera whimsically to see what will happen. No focus. No composition. No exposure setting. I just fire. My camera collects a load of photons. *Sometimes*, like this one, magic happens. I remain enchanted with the rich colors and tones. I love the fact that it's a photograph of light and light alone. It's not a photograph of a person, place or an object. It's just light, captured in a time line different from the one in which I live."–Syl

Check *PixSylated.com* for the continuation of LIDLIPS.

Join the LIDLIPS group on Flickr: *Flickr.com/groups/lidlips*

For more about the author, see
SylArena.com and *PasoRoblesWorkshops.com*

For Amy and our boys,
Tom, Vin, and Tony

⊰ LIDLIPS—The Birth ⊱

LIDLIPS started innocently and was fueled by equal parts of excitement and terror. This is how my good fortune works. If I had understood how popular LIDLIPS would become as a column on my blog, *PixSylated*, I likely would not have had the guts to start writing. Naiveté bests intellect once again.

Every Wednesday, Scott Kelby, the energetic leader of NAPP, hands over his blog, *Photoshop Insider,* to a guest writer.* When Brad Moore, who works as Scott's tireless assistant, asked me if I'd be willing to drive Scott's blog for a day, I was equally thrilled and terrified.

Believe me, if you're a creative, finding the balance between excitement and terror is the key. To say that I was motivated to come up with something meaningful for Scott's global audience is an understatement. Eventually, I focused my thoughts around the question: what would I most want to share with a passionate amateur or an emerging pro?

My answer on *Photoshop Insider* was 12 insights collected around the theme *Lessons I Didn't Learn In Photo School.* Over the course of the next eight months, I published another 88 LIDLIPS on *PixSylated*. What started as an innocent query has now become a constant companion.

So, *Scott*, *Brad* and all the *PixSylarians* who encouraged my efforts, *thank you*! I am humbled that you are now holding this collection of the first hundred LIDLIPS. And, yes, there are more LIDLIPS to come.

* Visit *PhotoshopUser.com* and *ScottKelby.com*.

⊰ Introduction ⊱

Every journey has a beginning,
but not necessarily an end.

I spent many years in photography school. Elementary school, high school, and college—I studied photography at every level. I even earned a BFA in photography. Yet the most important lessons I've learned about being a photographer did not come to me in the classroom. Rather, I learned them by living. I learned them by being a father, husband, mentor, business owner, and artist.

Compared to the world around me during my youth—some 40-plus years ago—our world today is awash in cameras. They are built into traffic lights, tucked into our phones, and orbit above us in outer space. Further, it is not lost on me that today's point-and-shoot cameras have more horsepower than the digital cameras used by the most forward-thinking pro photographers just a decade ago—and cost 99% less.

With so many cameras around us and such powerful cameras in our pockets, do we understand more about what it means to be a photographer? *I think not.* If anything, the advances in technology have pushed us farther from understanding the essence of writing with light.

Today, it is too easy to focus on gear, technique, and what others are doing. Instead, we should be focusing on how our images stand as reflections of who we are. We should be contemplating how making images leads to a more fulfilled life.

Even if you shoot solely for personal reasons, push yourself to understand that the world of photography is so much more than buttons and dials, so much more than Flickr and Web forums, so much more than learning to "fix it in Photoshop."

Since the earliest days of photography, almost 200 years ago, photography has been entwined with technology. Despite the wisdom of nearly 20 decades, many photographers still are not able to escape the pull of gear and how-to. For these unfortunates, photography is practiced as a series of techniques that produces another trophy to be added to the album. I am not among these technocrats.

Rather, I celebrate the view that photography is, at once, so much more and so much less than our human vision. Even though I now employ a completely digital workflow, photography remains for me a form of visual alchemy. I capture light and reconvey it on paper or on screen. I am an imagemaker and a storyteller. I live and I express.

Regardless of where you are on your journey as a photographer, I hope that my LIDLIPS will inspire you to think, to see, and to converse with fellow photographers in ways that you never have before. I long have been willing to explore the boundaries of photography. LIDLIPS is my latest expression of this journey.

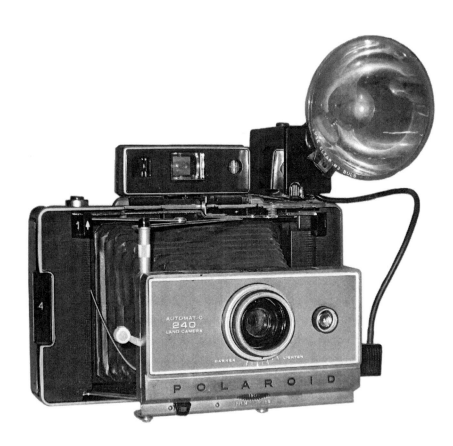

I shot my first photograph with a
Polaroid 240.

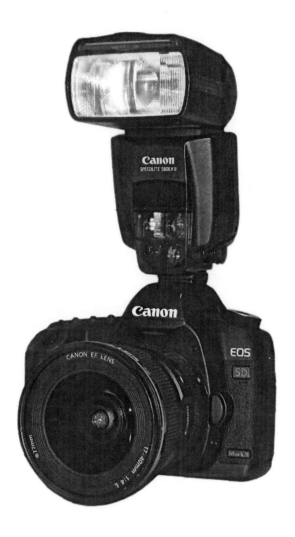

I shoot 30,000+ frames each year with a
Canon 5D Mark II.

⚜ The LIDLIPS ⚜

1.
If you can't be remarkable, be memorable.

2.
You are *not* defined by your photo gear
or your computer's operating system.

3.
Powerful photographs touch people
at a depth they don't anticipate.

4.
You have to let your images go out
into the world without you.

5.
Be the bee and cross-pollinate.

6.
Photography slices time. Photography gathers time.

7.
Learning to create photographs that *look* like your world
should be only a milestone, not the destination.

8.
"Coopetition" is a new business model that's here to stay.

9.
Wars have been fought to protect your copyrights.

10.
Your photographs have value. Don't give them away.

⚟ The LIDLIPS ⚞

11.
Your photographs have value. Give them away.

12.
Resist the temptation to become a pro photographer.

13.
Learning photography is just like
becoming fluent in a foreign language.

14.
Invest more in your education
than you do in photo gear.

15.
Understand that the meaning of *traditional photography*
is relative and always will be.

16.
Photographers are like dogs: they come in many breeds—
some are purebred, others are mongrels.

17.
Learn to think of the viewfinder as optional.

18.
Fail frequently.

19.
Don't worry about having a *defined look*.

20.
Understand that owning a photograph is different
than owning the rights to reproduce it.

⊰ The LIDLIPS ⊱

21.
MTV has changed the way
we look at and digest images.

22.
There is nothing more interesting to us
than photographs of other people.

23.
Be the director.
Your lens gives you the authority
(and the responsibility).

24.
There is no *I* in *personal,*
but there is one in *personality.*

25.
Your client has her own problems.
She doesn't want to hear about yours.

26.
Make up a story when shooting models.

27.
How we will be judged.

28.
You can seldom pay your mentors back.

29.
Beautiful light happens—sometimes.

30.
You can't create and edit at the same time.

⚔ The LIDLIPS ⚖

31.
Following the news can be an addiction,
and a huge distraction.

32.
Be open to your camera capturing realities
that you do not see.

33.
Just because someone has a strong opinion
does not mean that he's right.

34.
The hardest time to create is when you have to.

35.
Look at other photographers' work
more than you look at your own.

36.
Make photographs even when
you don't have a camera.

37.
Don't undervalue the
importance of your monitor.

38.
Accuracy is measured by
experience, not by color space.

39.
A camera and a thick dictionary
have a lot in common.

⚜ The LIDLIPS ⚜

40.
Just because someone already made that photograph
does not mean that you shouldn't.

41.
Light is like water—both are boring
until you put something in them.

42.
There will be times when you should take a break
and other times when you should push on.

43.
There is nothing to see in a world filled
entirely with light or entirely with darkness.

44.
No is the most powerful word in photography.

45.
Often the highest calling of a photographer
is to create memories for others.

46.
Creativity comes as a breeze
before it comes as a gale.

47.
When a client says,
"It's a simple job, don't worry,"
then it's time to worry.

48.
There's no direct connection between
the amount of time it takes to do a shoot
and the amount the photographer should charge.

⚜ The LIDLIPS ⚜

49.
Daylight comes in many colors.

50.
When NASA launches a rocket, it does not go straight up.

51.
If your camera was a pencil or a crayon,
you would find it easy to understand its limitations.

52.
There are times when you have to
hang it all out there—without any understanding
of where you are headed or whether it will work.

53.
Sometimes going to sleep is
the most creative thing you can do.

54.
If you want something way more than
the person on the other side of the deal, be wary.

55.
No matter how much you know, you'll never know it all.
So don't let not knowing hold you back.

56.
Hollywood is waiting to teach you how to light.

57.
Sometimes it is more important to
look like you know what you're doing
than to actually know what you're doing.

⊰ The LIDLIPS ⊱

58.
Sincerity, humility, and gentle persistence can open doors.

59.
The future is moving.

60.
Analysis Paralysis, Gear Anticipation,
and the Right Pursuit

61.
Humor contributes to global warming.

62.
Creativity and curiosity are fraternal twins.

63.
The more I look at my work, the less I like it.

64.
It used to be that photography was
just another way to make a mark on a piece of paper.

65.
If Columbus had been a photographer…

66.
If you follow someone else's path too long,
you'll lose track of where you left yours.

67.
Sometimes *good enough*
is better than *the best*.

⚜ The LIDLIPS ⚜

68.
Making yourself vulnerable
is a sign of strength.

69.
Never hesitate to share your guacamole.

70.
Starting is the hardest part.
Knowing when you are done is the second hardest part.

71.
When you've got nothing to lose,
don't be afraid to lose.

72.
Choose your peers wisely.

73.
Listen for answers to questions you didn't ask.

74.
Thank and *you* are two of the most
powerful words in the universe.

75.
Photography is proof that Darwin was right.

76.
Ignoring the manual is no longer manly.

77.
Play photography as a team sport.

⚜ The LIDLIPS ⚜

78.
Your *Decisive Moment* is still out there.

79.
Spend more time shooting than
you do reading Web forums and blogs.

80.
Photography from Tarzan's perspective

81.
The boldest creatives dance on
the tightrope when it has no safety net.

82.
If you don't believe in yourself,
then don't expect others to believe in you.

83.
Sometimes the best way to see something
is to not look straight at it.

84.
The enslavement of photography as a 2-D medium
will one day be thought of as ancient history.

85.
Get used to the idea of other people
running forward with your ideas.

86.
Embrace stress as the opposite of apathy.

⊰ The LIDLIPS ⊱

87.

The frames of history are meant to be broken.

88.

A camera is not a license to be a jerk.

89.

Kodachrome is dead. Long live Kodachrome.

90.

If you don't make a lot of photographs that
you didn't intend, then you're not working hard enough
or, maybe, you're working too hard.

91.

Look along the edges to find the in-between.

92.

The exotic is easy. The common is hard.

93.

Allow yourself to be captured.

94.

Ignorance is relative.

95.

Creativity mixes with safety about as well as
olive oil mixes with club soda.

96.

Don't confuse distraction with creativity.

⊰ The LIDLIPS ⊱

97.
There are many ways to cross the chasms.

98.
Mistakes happen. Get used to starting over.

99.
Listen to the resonance inside.

100.
Be prepared for your dreams to come true
(at least a few of them).

Dear Reader,

A few thoughts:

1. Resist the urge to read all the LIDLIPS in one sitting. They are best considered individually or in small groups.

2. Don't feel compelled to read LIDLIPS in any particular order. Be spontaneous. Jump around.

3. I've included a question or two at the bottom of every LIDLIPS.* Start conversations with your fellow photographers. Have a conversation with yourself.

Syl

P.S. Use this side to write down your thoughts.

If you can't be remarkable, be memorable.

Running with the pack won't get you any attention these days. You need to create ways for people to remember you. Often prospective clients don't want to work with *the best photographer* (perhaps because he's over-priced, egocentric, or inflexible). Rather, they want to work with a photographer with whom they have a connection. If you're memorable, there's a connection. Growing up, I often hated my unusual name and curly, red hair. Now, both are part of my persona as a photographer. My friend, Brian Smith, doesn't have it so lucky. Turns out that there are many photographers named "Brian Smith" who have brown hair.

In what ways are you remarkable?
How can you be more memorable?

**You are *not* defined by your photo gear
or your computer's operating system.**

Nikon vs. Canon, Mac vs. PC. Truth be told, none of this
matters to anybody other than the people who sell this stuff.
Nobody will look at your photographs and shout, "Yep! That
guy's a Nikon shooter on a PC. It just shows." If you're a
hard-core Nikonian or Canonista, *loosen up*; trade cameras
with a colleague and go make some great photographs with
another brand. Come to understand that your images are
reflections of you as a human and not of the machines you
used to create them.

Beyond gear and operating system, what other stereotypes
are used to categorize photographers?

**Powerful photographs touch people
at a depth they don't anticipate.**

If you want to be a strong photographer, strive to create images that touch people at a depth they don't anticipate. The most challenging part of this has nothing to do with the details of creating a photograph and has everything to do with living an enriched life. If you know tons about photography, but create shallow photos, then read literature, visit art galleries, learn ethnic cooking, volunteer, watch foreign movies, attend theater, travel, coach youth sports....

How do you to enrich your life—beyond photography?

**You have to let your images go out
into the world without you.**

If you feel compelled to talk every time you show your images, then stop talking. If you write long captions to explain your images online, then stop writing. Get used to the reality that you truly have little control over the perception of your work. Your images will be interpreted through the culture and life experiences of their viewers. To an American, a photograph of a woman in a white dress can suggest purity or marriage. To a Chinese, the same photograph could represent death and mourning. Stop trying to prop up your photographs with words. You have to let them go out into the world on their own. Doing so will make you a stronger photographer.

How does culture influence the interpretation of a photograph?

Be the bee and cross-pollinate.

There's incredible strength in a web that's woven of diversity. I recently attended a huge convention of wedding photographers in Vegas. I do not photograph a lot of weddings. Yet, I was invigorated by the vision and techniques of these combat-photographers-in-suits. It may be a long time until I shoot another wedding—but I now have a head full of ideas about how to elicit emotions from people, how to relax them in front of the camera, etc. As a commercial shooter, I'm happy to learn from wedding photographers. If you're drawn to landscape photography, get to know a sports photographer. If you shoot lifestyle, hang out with a still life photographer. If you're too shy to photograph people, volunteer to hold the light for a wedding shooter. Also, be the bee and help other photographers connect and cross-pollinate.

In what ways can you cross-pollinate more?

Photography slices time. Photography gathers time.

Our world is a motion picture that flows by us at a constant pace. The camera is not bound by this metronome. It can harvest very thin slices of time. It also can harvest very fat slices of time. I am as happy to shoot at 1/8000-second as I am to create blurry photos with slow shutter speeds. Photography enables us to see beyond the limitations of human vision. At its best, photography allows us to see a quintessential nature that's often too fleeting to be seen otherwise. Many, many times I've set out to create one image and realize afterward that I'd actually captured an unexpected and more powerful photograph. The quintessential often is discovered in hindsight rather than through intention. Fortunately, photography is very generous when it comes to giving us hindsight.

Ultra-fast or ultra-slow—why does a photographs's portrayal of time add power, depth, or uniqueness to an image?

Learning to create photographs that *look* like your world should be only a milestone, not the destination.

Embrace the fact that cameras see differently than humans. Accept that, even today, state-of-the-art tools and technology fall short of reproducing the entire gamut of human vision. The reality is that photography cannot perfectly record or portray the world as we experience it, yet this is typically the goal of most neophyte photographers. They measure the *quality* of their photographs by how closely the images match what the shooter experienced. If this is you, with time and practice, you'll come to understand that your photographs will seldom (if ever) match your reality. When that awareness comes, celebrate! You've finally reached the true starting line on your journey as a photographer. What lies ahead is the exploration of how you can create photographs that express rather than represent.

What criteria do you use to categorize a photograph as *good/bad, strong/weak, right/wrong*?

"Coopetition" is a new business model that's here to stay.

There is a new model for business floating around that says, "Competition + Cooperation = Coopetition." Old-school photographers (which has nothing to do with one's age) keep their two or three secrets close to the vest. The rest of us understand the power of relationships and sharing. There are times when you have to compete. There are more times when it's better to cooperate. Don't hesitate to refer a prospect to a competitor if you are truly unable to accomplish the job (either because you are already scheduled or because you are unqualified). It's quite probable that the next time your competitor can't take a job because she's already booked that your referral will be reciprocated. Share your knowledge freely and others will be glad to help you out when you ask.

How and when can you and your competitors
mutually benefit by working together?

Wars have been fought to protect your copyrights.

Copyright is a fundamental American right contained in the original version of our Constitution. Section 8 gives Congress the power "to promote the progress of science and useful arts, by securing for limited times to authors and inventors the exclusive right to their respective writings and discoveries." Every time soldiers, sailors, and pilots rush out to defend the Constitution, one of the principles they are defending is your right to have copyrights. The basis of copyright pre-dates other rights that were established later by amendments to the Constitution, such as: separation of church and state, protection against unreasonable search and seizure, the right of women to vote, etc. Understanding copyright is not optional. It is essential.

The sanctity of copyrights is eroding in our digital society.
Do you always honor the copyrights of others?

Your photographs have value. Don't give them away.

Resist the temptation to license work for free on the promise of future work or publicity. This is a common trap for new photographers. Your future relationship with a prospective client will largely be defined by your first transaction. If you give your photographs away to obtain the relationship, then your client will always expect you to give them away. Remember, if someone wants to use your photograph, then it has value. Find a way to get value back for its use. Money is great, but barter is fine too. Think about what your client has that you can use. Understanding the concepts of licensing is critical.

Why is it important that every transaction
have value for both parties?

Your photographs have value. Give them away.

An easy way to gain access to real shoots and to build your portfolio is to work with local nonprofit organizations. Find a cause that you believe in; and there will be a nonprofit that can use your services. Nonprofits will often jump at your offer to donate professional photography. The key here is that you initiate the contact and that the cause is one you believe in. On the other hand, if you're solicited by a nonprofit and asked to work for free, be skeptical and ask the solicitor if he or she gets paid by the organization. Nonprofits pay for legitimate business expenses all the time. Make your decision to support their cause accordingly.

When is it appropriate to expect that a nonprofit will pay for the use of photography as a legitimate business expense?

Resist the temptation to become a pro photographer.

In the purest sense an *amateur* is someone who works for the love of a trade or art rather than for money. Choosing to remain an amateur photographer is no measurement of your skill or commitment to the craft. The photography world is filled with unskilled professionals. Thinking that you want to be a professional shooter because you really *love* photography is absolutely the worst reason to get into the business. I guarantee you that if a *love* for photography is your main motivation, the economic realities of the industry today will pound your passion into the ground. If, however, your inner voice continues to shout, "This is what I want to do", after your passion has been beaten out of you, then you are truly hearing the call to the trade. Let me be the first to say, "Welcome."

Is it possible to be a successful photographer
without being a professional?

⊰ 13 ⊱

**Learning photography is just like
becoming fluent in a foreign language.**

A lot of time and persistence is needed to become conversational in a foreign language. At the beginning, you learn some words and a bit of simple grammar. You babble like an infant and struggle to write a simple sentence. Over time, you learn more words and more grammar. To be truly conversational, you study literature, both classic and contemporary. Then you practice more vocabulary, more grammar, more speaking and writing. You forget old lessons and have to relearn them. Surprisingly, one day, you realize that you are fluent and have been for a while. You think and create in your new language without hesitation. Rather than translate word-by-word, you're expressing without hesitation. The path to becoming a competent photographer is just the same.

If photography is a language, how broad is your vocabulary?
How much do you know about photography's *literature*?

**Invest more in your education
than you do in photo gear.**

I've taught workshops where students showed up with bags
of gear worth many times the value of the gear in my bag.
Yet, they hadn't a clue about how to craft a memorable pho-
tograph. At every photo trade show I attend, I am reminded
that there are thousands of people who feed their families by
trying to sell me solutions to problems that I don't have. I'm
also amazed that many shooters are far more fascinated with
the specifications on a new lens or flash than they are with
learning about which books to read or seminars to attend. It's
far easier for an experienced photographer to make a great
photograph with mediocre gear than it is for an inexperi-
enced photographer with great gear.

Where do you concentrate your efforts—
getting more gear or getting more experience?

Photographers are like dogs: they come in many breeds—some are purebred, others are mongrels.

Is there a right or a best way to be a photographer? I think not. I am a pictorialist—a photographer who creates images rather than takes them. I've learned to shape light and do so freely whenever I need to. I won't hesitate to change or fix something in Photoshop if need be (although I strongly prefer to get it right at the time of capture). Other shooters are documentarians—they strive to capture images with minimal influence on the event being photographed and process them in a way that minimally alters the file. When I create photographs solely as a personal expression, I am working as an artist. When I create photographs to meet the needs of others, I am a businessman. Some photographers shoot only food or fashion or sports. Other photographers shoot anything they can. None of these is right or wrong, better or worse.

Using the names of items you can buy in a hardware or grocery store, how would you describe yourself as a photographer?

Learn to think of the viewfinder as optional.

If you don't regularly make photographs *without* looking through the viewfinder, start today. Learn how your lens sees without looking. Become more spontaneous. Hold your camera up over your head—like a paparazzo. Shoot from the hip (literally). Go for the worm's-eye view. Stop gazing at the LCD after each shot. Try this. Cover the viewfinder and LCD with tape—except where the histogram shows (so you can make good exposure decisions). Then shoot for a day or a week without ever looking through the lens. I'm sure you will come up with many great images that show you the world in a way you haven't seen before.

How does learning how your camera sees help
you understand more about how you see?

Fail frequently.

One of the gateways to being truly successful is not being afraid of failure. A friend laughed at me long ago and said, "Syl, you won't make that mistake again. You'll make a new and bigger mistake." I've been practicing this mantra for years. Much of my creative growth has emerged from the ashes of my efforts. Study your *mistakes* and use them to expand your vision and understanding of the photographer's life.

How have you grown through your
mistakes as a photographer?

Don't worry about having a *defined look*.

The only consistent look I have is a head of crazy, red hair that does just about whatever it wants each day. As for my photography, I've gone on record as saying, "If I were a tool instead of a photographer, I'd be a Swiss Army knife." Art directors in New York, Los Angeles, and the other major media markets tend to hire commercial shooters who have a very defined style. I think it's because they need to eliminate the possibility of making a mistake. They want to know that when they hire a certain photographer, they'll get the certain look that they've already sold to their client. A high-dollar shoot is definitely not the place to re-invent yourself. Of course, the vast majority of us don't live in or shoot for people in New York or Los Angeles. For us, the danger of having a defined look is that it will become that comfy place that deteriorates into a creative rut. Actually, that's a huge danger for NY and LA shooters too. If your look is defined, start unraveling it before your look morphs into a rut.

Do you have a *defined look*? If so, are you working to grow beyond it? If not, are you working towards one?

Understand that owning a photograph is different than owning the rights to reproduce it.

At the moment of creation (when the shutter button is pushed), a photograph is intellectual property and the copyright for that photograph belongs to the photographer. Unlike real property (your home) and personal property (the items in your home), you cannot touch intellectual property. Intellectual property is also different than real and personal property in that it can be reproduced easily (many copies can be made, each one exactly like the others). A photographic print is a physical object and a type of personal property. However, owning a photographic print does not necessarily give the owner the right to reproduce the photograph. This right of reproduction remains with the copyright owner—a right that can be licensed many times. As a commercial photographer, I do not sell my photographs. Rather, I license specific rights of reproduction to clients. As a fine art photographer, I sell my photographs (as prints). The difference between the *photograph* (an image) and the *photograph* (a print) is something that you'll explain to clients for the rest of your life.

Using terms of their trades, how would you explain copyright to a homebuilder, a doctor, and a salesman?

**There is nothing more interesting to us
than photographs of other people.**

We are voyeurs at heart. We are curious about each other.
When it comes to photography, there is nothing we are more
interested in looking at than other people. If you want to
increase your chances of earning a living as a photographer,
you have to learn to photograph people. For many, this is
their Mount Everest—a nearly-impossible task that drives
them to photograph landscapes, nature, or still lifes. For years
I said, "If it can talk to me, then I don't want to photograph
it." On the journey to becoming a people photographer,
you may start by making candids because you're shy. If you
don't push through, your photographs will reflect your timid
nature. The people photographs that viewers connect with
are the ones where the sitter connected with the photogra-
pher through the lens. In this way, photography is just like
life; it ultimately gets down to connections.

Why are we so fascinated with other people?
Why are we afraid of talking to them?

**Be the director.
Your lens gives you the authority
(and the responsibility).**

Every sane person fears looking bad in a portrait. If your sitter looks worried, it's because he doesn't know what to do with his hands, or how to stand, or where he should look. Be the director. Encourage. Reassure. Demonstrate. It's up to you. Your sitter sees a piece of glass at the end of a black tube. You see what the camera sees. Even if you haven't a clue, conveying a sense of confidence is key.

If you are not comfortable being the director, why should your subject be comfortable in front of your camera?

**There is no *I* in *personal*,
but there is one in *personality*.**

It's a common chant that "every photographer needs to shoot personal work." I agree. Yet, I think that a lot of personal work, mine included, can be really boring. If it's too personal or too subtle, your personal work becomes a visual secret. Personal work is about pushing your creative boundaries. Rather than shoot personal work, I shoot work that reflects my personality.

What is the difference between *personal work*
and *work that reflects your personality*?

**Your client has her own problems.
She doesn't want to hear about yours.**

It really doesn't matter if your client is a stressed advertising executive, a nervous bride-to-be, or your mother's second-cousin. No one deserves to hear about your problems on a shoot. Yes, it is tough to keep a calm demeanor when you've just screwed up royally or your gear has gone on the fritz, but if you want to be a pro, then be a pro. Keep your problems to yourself—all the while smiling and chatting as if everything is perfect.

What statements do you have ready to go in case a problem comes up on a shoot and you have to talk over it?

Make up a story when shooting models.

More true confession time: I have a really hard time making photographs of people if I don't know their story. When I'm photographing a model in a workshop or another contrived situation, I need a connection. So, if I don't have a relationship or a purpose (other than to make a photograph), I create a story line in my head and then share it with the model. Try it. Next time you're stalled on a model shoot, create some story about the sitter—a bit of history, a perspective, or an attitude. Share that bit with your model. I bet your photographs will start to flow after that.

If you are uncomfortable talking to people you don't know, then what can you do so that they are not strangers?

How we will be judged.

Many shooters spend a lot of time trying to shape the perception of their careers by building the *right* relationships and seeking the *right* opportunities to show the *right* images. In the long run, there's little anyone can do to truly direct how the world responds to their work. Ultimately, your career as a photographer—amateur or professional—will be defined by the lives you touch through the images you make. Chances are good that you'll never know what the final score is either.

How do you want your career as a photographer to be defined?
Are you working in that direction?

You can seldom pay your mentors back.

Our lives are interwoven into the fabric of many others. At times, we lead. Other times, we follow. You can seldom pay back the debt owed to those who carried you forward. Instead, pay their wisdom and help forward to another. Blog. Teach. Coach. Do anything you can to enrich the lives of children. Be a lighthouse for others. I continue to marvel at the fact that the more I give, the more I'm helped by others.

Who are your mentors?
Who are you mentoring?

Beautiful light happens—sometimes.

Without light, a photograph is just a black sheet of paper. When beautiful light happens, the photographer's work is half-done. More often it's up to the photographer to make the light beautiful. Don't hesitate to mix up the light as you need it to be. A kitchen may have water, flour and yeast. It's the kneading of the baker that turns them into a loaf of bread. Think of light as another ingredient that needs to be shaped, bent, filtered, focused, softened. Be the baker.

Are you willing to modify light?
Do you know how?

You can't create and edit at the same time.

Creating and editing are two completely separate tasks. Few photographers are good at both. Among pros, there are shooters and there are picture editors. Trying to edit while creating is like trying to drive by pushing on the gas and brake pedals at the same time. Create. Do something else. Then edit. Better yet, have someone else edit.

Are you better at editing someone else's work or your own? How does having a unique perspective affect the edit?

⇥ 31 ⇤

**Following the news can be an addiction,
and a huge distraction.**

The world has more distractions than ever before. Achieving your goals—personally and professionally—requires that you stay focused on what is most important to you. I'm surprised that, for many, staying on top of the latest news is an obsession. I'm surprised because there is so little in the news that we can actually do anything about. I've come to realize that if I focus on matters that I can't change, then I'm not focusing on the issues that I can change.

When it comes to your career, what distracts you?

**Be open to your camera capturing
realities that you do not see.**

Sometimes we try too hard to make photographs. We juggle the rule of thirds, the inverse square law, and depth of field. We fret about focus and exposure. Rather than flow, we falter. Sometimes, it's better to just push the shutter button. Push it and see what happens. Push it and discover that the camera sees a reality all of its own. Sometimes the camera's vision is empty. Sometimes its vision is enchanting.

How does your camera see differently than you do?

The hardest time to create is when you have to.

The writer stares at the blank page. The painter stares at the blank canvas. The blogger stares at the blank screen. Being creative when you don't have to seems easy. Creating on demand is hard. If you're blocked, just start. It really does not matter what you do. Starting is the key. Create and don't edit. Then keep on creating. Your drops of inspiration will merge into a stream and then into a river. Your creativity will be unleashed and flow freely. The difference between creating spontaneously and creating on demand is that the former starts without notice and the latter has to be jump-started. Not being afraid to start is your jumper-cable.

Where can you go and what can you do
to put yourself into a creative space?

Look at other photographers' work more than you look at your own.

Like Narcissus staring at his reflection in the pool, sometimes we spend way too much time looking at our own work. If you want to improve your photography, spend more time looking at the work of other shooters. Decode the light. Think about what's in the frame. Think about what's not in the frame. Study the gesture, the expression, the nuance. Put yourself in the moment, the situation, the set. Close your eyes and be that other photographer for a bit. Open your eyes and be yourself.

Beyond photography, how can looking at paintings, listening to music, or watching dance improve your creativity?

Make photographs even when you don't have a camera.

Photography has way more to do with seeing than it does with driving a piece of hardware. Practice your skills as a photographer even when you don't have a camera. Make mental pictures anywhere at anytime. Study the light around you. Watch the gestures and expressions of people across the restaurant. Look for geometry in surfaces and shadows. To make photos in your head, pick a word and say it to yourself every time you take a mental picture. My word: *Snap.*

There are pictures to be made everywhere.
Are you open to seeing them?

Accuracy is measured by experience, not by color space.

A colleague asked an interesting question recently: Was it fair for me to increase the saturation of colors in my photos so that there are now colors visible that did not exist in the original capture? The teetering point between *documentation* and *interpretation* is always a space that stimulates such great thought. Fair? Absolutely. The latest digital cameras still only capture a fraction of what I can see. When there are colors in the scene that are beyond the range of a camera's sensor, the circuits in a machine make decisions about what is recorded. A technological limitation should not be the defining measure for the accuracy of the color in my photos. Rather, it's how my photographs portray my recollection of the experience that is the defining measure of accuracy.

Why is photography not a perfect record of your vision and experiences?

A camera and a thick dictionary have a lot in common.

If one believes that reality can be captured, then neither a camera nor all the words in an unabridged dictionary are an efficient trap. It's not the light-gathering machine or the vocabulary list that convey human experience. Rather, it is the efforts of the photographer and the writer that distill experience into the reality that is communicated. The question of whether the photographer and the writer convey their reality or create a new one remains.

Why is it the photographer and *not the camera* that does the communicating?

Just because someone already made that photograph does not mean that you shouldn't.

Often there is a great prejudice among emerging photographers (particularly young emerging photographers) against photographs that mimic or are derived from the work of other (usually famous) photographers. Curious. I do not recall being reprimanded in grade school for not writing original prose. Rather, I often received gold stars for writing just like every other kid in the class. Likewise, if the scene calls to you, then you should not avoid photographing green peppers in a bowl (like Weston) or the Flat Iron building (like Steichen). In a long life there is truly very little for which an individual can take sole credit. We stand on the shoulders of those who came before us. Without knowing, we inspire others and draw inspiration simultaneously. Just as there is nothing wrong with preparing a meal pioneered by a famous chef, there is nothing wrong with venturing into the realm of other photographers. Explore their territory. Experience their vision. Eventually, you'll realize that you've wandered off the established path onto one of your own.

Whose shoulders have you stood upon?
Who is standing upon yours?

**Light is like water—both are boring
until you put something in them.**

Pure distilled water is odorless, colorless, and tasteless. Pure
white light is about as interesting. For water, it's the minerals
and other impurities that give it taste. For light, it's the atmo-
sphere—natural or created—that gives it character. We love
the light at sunrise and sunset because of the warmth. We
shiver at the blue light during snowfall. As a photographer,
know that you don't have to take light as it comes straight
from the sun or straight from the flash. Gel it. Scrim it. Filter
it. Bounce it. Add the impurities you need to get the flavor
you want.

When light does not have the character you want,
do you wait or take control?

There will be times when you should take a break and other times when you should push on.

As a creative you will frequently get to the brink—the brink of total exhaustion, the brink of losing all confidence in your work, the brink of deciding that you've been on the wrong path for a while. There will be times when you just have to put it all down and do something else—for a short bit or a long while. There will be other times when you just have to power through and get the job done. Fatigue, self-doubt, and losing the way are recurring parts of the creative journey. Not knowing if you should take a break or push on is also part of the path. Between the two, stopping and continuing, there's a 50/50 chance that you'll make the right choice.

When deciding between stopping and pushing on, how do you sort it out?

≈ 43 ≈

**There is nothing to see in a world filled
entirely with light or entirely with darkness.**

Can you see anything on a page that is pure white or pure
black? Of course not. Understand that the intersection of
light and dark creates the images we see. Sometimes this
intersection is subtle. Other times it is bold. Contrast—the
merging of light into darkness—is what makes light interest-
ing. Shadow is just as important as highlight. Color is several
flavors of light and dark dancing together. Learn to see this
way.

Light can contrast in many ways.
What types of contrast do you see around you now?

***No* is the most powerful word in photography.**

Somewhere in the unsearched part of human DNA there must be a few bits of code that say, "Photographers are all the same," and "Photographers like to work for free." Virtually all non-photographers believe one or the other, and a vocal minority believe both. Learn to say *No* without hesitation. Learn to say *No* gently and with authority. Practice phrases like, "No, I won't shoot your wedding. I am a still-life photographer." Or, "No, I don't see how your diminishing reader base means that I should work for free." You don't have to be rude about it. The sense of confidence behind your *No* tells people volumes about the strength of what you will do.

Are you willing to say *No* even if it means you won't get a job?

**Often the highest calling of a photographer
is to create memories for others.**

Many photographers feel that they have to make a state-ment, that they have to show or tell the world something not known before. Many critics feel that without a statement a photograph has no value. The truth is that, relative to human history, there is little that has not been said or shown before. Yet memory remains one of the most transient bits of human existence. Memories are the only time machine we have to transport us into the past. Often, the power of a photograph is that it stimulates memories. This power may serve an audi-ence of only one: one person, one family, or one community. Capturing moments that stimulate memories is one of the greatest gifts a photographer can offer.

Why do we turn to photographs to recharge our memories?

**Creativity comes as a breeze
before it comes as a gale.**

Inspiration—the creative breath—comes freely when it wants to and often hides when you beckon it. Creativity will start softly, like a gentle breeze. And, like a breath of spring air, creativity may stop suddenly and then change directions before returning. As you open yourself to the creative flow, its intensity will build until it seems like you are being swept along in a gale. Then, without warning, the storm will pass and you'll be left standing, alone, uninspired again.

Where and how does your inspiration come to you?
Do you put yourself in that place and state-of-mind often?

**When a client says,
"It's a simple job, don't worry,"
then it's time to worry.**

It always cracks me up when a client says that he has a *simple job* for me. Simple? How would he know? If he were a professional photographer, he wouldn't be calling me. The fact that he says the word "simple"—just before describing a complex set of shots—tells me that he hasn't a clue. If he hasn't a clue, then he's going to think my fees are outrageous. If I want the job, it's up to me to help him understand that simple is not always simple. Figuring out how to convince him of that is when I start worrying.

When is it necessary to explain that a job is not simple?
When is it best just to get the job done?

**There's no direct connection between
the amount of time it takes to do a shoot
and the amount the photographer should charge.**

With the exception of event photography (where I agree to shoot for a certain number of hours), I never allow clients to think that I charge a certain rate per hour. This is something that every photographer should avoid. As I see it, my clients hire me to create images that fit their needs. Time on the shoot or in post-production is not a direct component of the value of those images. I've invested heavily in training and gear over the years. If I can get a job done in an hour when it takes a less-experienced shooter three hours, does that mean that my work has less value?

What gives a commercial photograph value?
What gives a fine art photograph value?

Daylight comes in many colors.

To use the term *Daylight* when describing the white balance
on a digital camera or the color balance of a film stock is a
misnomer. Lie in bed and watch the color of your walls
change as the sun rises. Walk through a forest and observe
how daylight changes as it is filtered through and reflected by
the canopy of leaves. Think about how daylight is changed
when it bounces off the surface of the moon or cascades
through clouds. Get to know daylight in all its colors. Then
come to understand how to use light modifiers and to switch
the color balance settings on your camera so that you can
change the light that is available to you into the daylight that
you want.

Is it always appropriate to change the color of light?
When is it not?

When NASA launches a rocket, it does not go straight up.

We all want to think that when NASA launches a rocket it goes straight up into space. The truth is that the contraption begins to fall sideways as soon as it leaves the launch tower. As it gathers speed, it continues to arc over. By the time it leaves Earth's gravity, the spaceship has actually traveled much farther horizontally than it has vertically. It's also important to consider the fact that the vast majority of the fuel used to launch the rocket is expended in the first couple of minutes after the launch. Seems to me that getting a career started as a photographer is a lot like launching a rocket.

Where are you on your trajectory as a photographer?

**If your camera was a pencil or a crayon,
you would find it easy to understand its limitations.**

No one expects a pencil, a crayon, or a box of watercolors to produce photo-realistic images. Yet, in the hands of a truly skilled artist, they can. We often look at our photographs and think "that doesn't look like what I saw." You have to embrace the fact that cameras, even the most modern cameras, can only record a fraction of the colors and tonal range that we can see. Once you come to embrace the limitations of your camera's technology, you'll soon find ways to fly over those boundaries.

How does an understanding of your camera's limitations help you do more than you could without that understanding?

**There are times when you have to
hang it all out there—without any understanding
of where you are headed or whether it will work.**

Being a creative means that you'll often find yourself racing down paths that you've never ventured onto before. Without knowing why, you'll respond to the breath of inspiration by doubling your efforts. As you race forward without any understanding of what lies ahead, a touch of panic will try to sneak in. You'll think, "Where am I going?" You'll briefly worry, "What if this doesn't work?" Push those questions aside and continue charging ahead blindly, continue charging ahead creatively. The moment you start to deal with these fears is the moment that your creativity evaporates.

How does doubt limit your creativity?

⊰ 53 ⊱

**Sometimes going to sleep is
the most creative thing you can do.**

On any number of occasions, I've reached the end of a creative session absolutely exhausted. Thinking, feeling, believing that I had nothing more to give, I figured the job complete. Time and time again, I've woken up in the morning with a deep pool of energy and enough new ideas to fill a warehouse.

Why is stepping away an important part
of the creative process?

**If you want something way more than
the person on the other side of the deal, be wary.**

I once met a fellow who I thought could make a huge difference to the arc of my career. Call him a *rainmaker* or a *center of influence* or a *master networker*. This guy had experiences and contacts that I could only dream of. Turns out that I wanted a friend with these contacts so much that I ignored the warning signs—the never-ending stream of stories, the nonstop talk about himself, the inconsistencies between the first and second time that I'd hear a story. It unraveled when I came upon someone else's byline on a famous photo that I thought my friend had made. We had discussed his being at the event and the capture of the iconic image. The moment I realized that he had taken credit for another shooter's photograph was the moment that I also realized I wanted to be his friend way more than he wanted to be mine.

How can you improve your network of friends,
both inside and outside the world of photography?

**No matter how much you know, you'll never know it all.
So don't let not knowing hold you back.**

Don't let thoughts like "I have so much more to learn" or
"I'm not ready yet" hold you back. The truth is that if you
wait until you're ready, you'll never start. The digital evolution
in photography has been a great leveler. No one understands
every detail of Photoshop—not even the guys who invented
it. No one understands every control option of the latest
DSLR—not even the guys who make the DVDs about them.
Get used to the idea that you'll have to ask others for help.
Get used to the idea that you should offer help freely. Every-
one of us is ignorant to some degree or another when it comes
to technology. Accept your weakness and keep shooting.

How willing are you to ask for help?
How willing are you to give it?

Hollywood is waiting to teach you how to light.

If you really want to learn how to light, go to the movies and think about the light you see. As still shooters, we think in terms of lighting one spot for a fraction of a second. On the set of a motion picture, they have to light a broad area so the actors can move through it without casting unwanted shadows or walking out of the light. Put another way, grips and gaffers do their jobs with intention—there is a look the director wants and their task is to deliver that vision through lighting. Virtually every lighting tool we still shooters think of as new or unique has been used in Hollywood for decades. Gels, scrims, shiny boards, flags, gobos—they all came to us from the movies. Even the newest lighting tools—like LED panels—were adopted by the movie guys first. Hollywood understands that the camera records light and shadow differently than we see it. They don't fight physics. Rather, they've invented tools and techniques that change one reality into another. Learn what they do and how they do it. Your vision as a photographer will expand accordingly.

Watch a movie and deconstruct the light as the story plays. How do the styles of lighting influence the story?

**Sometimes it is more important to
look like you know what you're doing
than to actually know what you're doing.**

Maintaining the confidence of your client is key—even when
your shoot is crashing. Once I was on a wedding shoot with
the bride and three attendants staring right into my lens
when my camera mysteriously locked up. Rather than change
the mood and say I had a problem, I went through the
motions of taking a few more frames—even though nothing
was happening. As the group moved to the next spot, I went
to my gear bag and changed camera bodies. Stopping to
figure out the problem (a bad CF card) would have appeared
as if I didn't know what was going on (which I didn't at the
time). Problems happen during shoots. How you respond
is a measure of your professionalism. Maintaining an air of
confidence and control in front of your clients is key. Have
an SOS phrase in the back of your head— something like, "I
see an new opportunity here. Let's break for a few minutes so
that we can set up for it."

When is it unprofessional to say that you have a problem?
When is it unprofessional to *not* say that you have a problem?

**Sincerity, humility, and gentle persistence
can open doors.**

Across the decades of my professional life, I have had a
number of mentors. Not surprisingly, none of them walked
up to me and said, "I want to give you my time and my
expertise, and I don't want to charge you anything for it."
I've long wanted to believe the old saying, "When the stu-
dent is ready, the teacher will appear." Sure, he may appear.
But getting his attention is a completely different matter. My
experience is that the three keys to opening up a relation-
ship with a mentor are sincerity, humility, and gentle per-
sistence. If you are not sincere in your desire to be the best
photographer you can be, then there's no point in having a
mentor. Being humble means you respect yourself and your
mentor. It means being honest about what you don't know
and haven't done. It means understanding the definition of
sycophant and not going there. Even when your head and
your heart are in the right place, you'll still need to convert
your hero into your mentor. Typically, this happens slowly
over time. It comes through persistence, gentle persistence.
Remember that you are not and never will be critical to the
success of your mentor's career. That he has taken you on is
more a testament to the gifts he received from his mentors
than it is of you. Still, if you are worthy, do not hesitate to
knock and to come back and knock again. Eventually your
persistence will open the right door.

If you are *not* sincere, humble, and gentle in your pursuit
of a mentor, what can you do to become so?

·

The future is moving.

While I'm not ready to say that the death of still photography is imminent, it is apparent to me that the future of photography is in motion. Observe how the rapid growth of the Internet as an advertising channel has caused widespread devastation in the newspaper and magazine industries. As access to broadband continues to spread, and as mobile tools like Apple's iPhone and Amazon's Kindle continue to evolve, there's an ever-increasing opportunity to use motion over still photography. Not too many years ago, the moving photographs on the walls, desks, and newspapers of Harry Potter's world seemed quaint. I see them now as an insightful glimpse into our future. If you are young, photographs that move and speak and sing are your future. If you are an old-school shooter, like me, now is *not* the time to put your head in the sand about how the world has once again changed its expectations of what photographers do.*

* For a more detailed monologue, read: 'Digital Photographers, Welcome Back To 1999' on *PixSylated.com*.

In the time line of photography, how has the world changed its expectations of what photographers do?

Analysis Paralysis, Gear Anticipation, and the Right Pursuit

An earnest dad came up to me and asked my thoughts on which DSLR was best suited for photographing his children playing soccer. He had boiled his options down to one camera that shoots 3.6 frames-per-second and another that shoots 6.2 frames-per-second. Oh, and there was the possibility that one was coming out in a month or two that would shoot close to 10 frames-per-second. He'd been looking into cameras for the entirety of his kids' soccer season. I offered two suggestions. The first was to get over his Analysis Paralysis. The second was to buy the best camera he could afford at the moment. I came away from the conversation wondering how many great shots of his kids he had missed because the pursuit of the camera had overtaken the pursuit of the photograph.

When you find yourself caught up in technical specifications, how do you let go and refocus on your images?

Humor contributes to global warming.

While we come in many shapes, sizes, and colors, it's evident that the smile is universal. As a photographer, use this knowledge with a purpose. Pointing a lens at someone can be intimidating, on both ends. If you find a way to connect, the intimidation will evaporate. Crack a joke. Make fun of yourself. Do it knowing that we can't laugh without smiling.

How does humor melt barriers and
build bridges between people?

Creativity and curiosity are fraternal twins.

Creativity and curiosity were born from the same mother. They may look different, but at their core they are the same. You cannot be creative without having a strong curiosity. "If I do this, what will happen?" is at the core of the creative's journey. Add spontaneity as a playmate to the pair of twins and you have an explosive mix.

Why is creativity not limited to the arts?
How is creativity important to science and business?

The more I look at my work, the less I like it.

When I'm shooting, the photos that I get most excited about are the ones that show me something new or take me to a level I've not climbed to before. Yet, the more I look at these images, the less new they become. The more I make these types of images, the less challenging they become. When the images become commonplace, I lose interest and my enthusiasm for them slides. It's not the photo that's changed—it's me. Like a high school crush, when the infatuation is over, my interest moves on. I've stopped worrying about this. Time can be a great filter. I've come back to my images, sometimes days later and sometimes years later, and found a newly-kindled enthusiasm for what I see. Now, when I look at my work and don't like what I see, I ask if I'm looking at it too much rather than too little.

How can you tell if you are looking at your work too much?

**It used to be that photography was
just another way to make a mark on a piece of paper.**

For the first 150 or so years of its history, photography was just another way to make a mark on a piece of paper. (Yes, some of the early processes marked up plates of metal or put an image on a piece of glass, but the main medium of delivery was paper.) As novel as photography was, for the first half-century of its existence, photography wasn't even a *good* way to mark up a piece of paper. During most of the 1800s, a piece of charcoal or a tray of watercolors could deliver more tonal and color fidelity than photographs. Of course, all that eventually was sorted out by chemists and businessmen. Photography has long been able to deliver images that vividly portray the world around us—still mainly on paper for a while more.

What lies beyond metal and glass plates, sheets of paper, and electronic screens when it comes to displaying photographs?

If Columbus had been a photographer...

Photography is a process of visual exploration. Start with a concept or a bit of inspiration. Then make a photo based on what you see and your assumptions about how the camera will respond to it. Take what you learn from that photo and make another. And another. Continue to explore, evaluate, and fine tune your efforts. The journey of a photographer often heads across distant horizons into uncharted territory. Don't fret if your shoot veers off in a completely new direction and ends up someplace completely different than where you originally intended. I bet that Columbus would have made a fine photographer.

As a photographer, are you an explorer
or someone who navigates by GPS?

**If you follow someone else's path too long,
you'll lose track of where you left yours.**

One of the hardest parts of living as a photographer is to stay
true to yourself. In a world that is awash in images, it's all too
easy to want to do what more successful photographers have
done. Every photographer veers off into the territory of his
peers, his mentors, and his heros from time to time. Yet, each
one of us has our own path—our own vision—that's wait-
ing to be explored. When you are starting out, it's natural to
make photographs that others have made. Eventually though,
you'll need to find your path and have the courage to stay on
it. As you venture on, when you're tempted to chase someone
else's success, remind yourself that if you follow their path too
long, you'll lose track of where you left yours.

What are you doing to explore your own vision?

**Sometimes *good enough*
is better than *the best*.**

Having the best (most expensive) gear or producing the best (most technically complex) photograph is not always the best (most beneficial) way to go. Having or doing the best often means spending twice as much money or time just to get a little bit more. Sure, in the Olympics being .07% faster than your competitor can be the difference between gold and silver. In photography, avoiding that obsession can be the difference between becoming an expert shooter or an expert on gear specifications. It can be the difference between making money on a shoot or having to reach into your pocket to subsidize the job. *Good enough* does not always come in second behind *the best*.

Does your camera bag contain tools or status symbols?

Making yourself vulnerable
is a sign of strength.

It takes guts to open yourself to the criticism of others. "I may be good, but I'm not as good as I can be" is a hard thing to say with confidence and enthusiasm. The more you are able to open yourself to commentary, the better you'll become. Actors have directors. Writers have editors. Athletes have coaches. Pro and amateur alike, we all need to make ourselves vulnerable to the criticism of qualified observers. Doing so is a sign of strength. Not doing so allows fear to win.

When your work is critiqued, are you defensive, mildly accommodating, or truly interested in the thoughts of others?

Never hesitate to share your guacamole.

I was having dinner with a large group of photographers after a workshop when I noticed that the fellow next to me was eyeing the huge mound of guacamole that had arrived on my plate. "Do you like guacamole?," I asked. The enthusiasm in his reply left no doubt. So, despite my lifelong love of southwestern cuisine, I gave him the whole pile. A few years later, I was attempting to contact an internationally-known photographer in Manhattan. Turns out that the fellow to whom I'd given my guacamole had moved to New York and become his studio manager. Rather than being tossed out, my letter was put before the photographer and I received a personal reply. Never hesitate to share your bounty with another photographer. A couple of smashed avocados might just be the ticket that gets you to the next level.

Do you think your images or your relationships will get you farther down the path as a photographer?

Starting is the hardest part.
Knowing when you are done is the second hardest part.

Sir Isaac Newton, the 17th-century physicist, could have been a career counselor for creatives. He demonstrated that something at rest tends to stay at rest and that something in motion tends to stay in motion—until acted upon by an outside force. For the creative, getting a project started is the hardest part. Coming up with the initial bit of inspiration and taking the first few steps at converting the inspiration into action is the challenge. Then, once you're in the groove and the creative stream is turning into a river, you'll hit the creative's second-hardest challenge: figuring out when you should stop.

When it comes to creativity, do you brake or break?

≒ 71 ≓

**When you've got nothing to lose,
don't be afraid to lose.**

It's not failure that holds us back; it's the fear of failing. More often than not, when we're afraid of failing, we won't even try. Or, if we try, we'll try timidly rather than boldly. The ironic part about this is that when we're starting out as photographers and have virtually nothing to lose is when we're the most fearful. If you have nothing to lose, put your fear in a box and shoot like you've never shot before.

Is your journey as a photographer controlled more
by the fear of failing or the fear of not trying?

Listen for answers to questions you didn't ask.

Recently I was interviewed by a college student majoring in photography. Her assignment for *Photo Business Practices* was to talk with a professional shooter about the development of his or her career. When asked, "Which of your shoots was most instrumental in changing your career?," I replied, "There's never been a shoot that changed my career as much as the relationships that I've developed along the way. This is a business of relationships, not shoots." I'd given her the most valuable bit of insight I have about the world of professional photography. She totally missed my message because it was an answer to a question she didn't ask.

If photographers are visual people, why is it
more important to be a listener than a visionary?

**_Thank_ and _you_ are two of the most
powerful words in the universe.**

Never underestimate the value of being respectful. When my
boys were young, I told them, "*Please* is the magic word that
gets grown-ups to do what you want them to do." Likewise, a
sincerely delivered *Thank you* can turn a disinterested worker
into a strategic partner. The return on just a bit of respect
can be huge. As strange as it sounds, being courteous these
days can be a way to distinguish yourself in the market—with
clients and vendors alike.

How can respect and courtesy be seen
as strengths rather than as weaknesses?

Photography is proof that Darwin was right.

Today we are some 30 years short of the bicentennial of photography's invention. The reign of paper as the most widely used delivery medium for photography is ending. Now more images are delivered as photons than as droplets of ink. The Internet has morphed from being the secret realm of academics and soldiers into being the world's largest public library. Devices like the iPhone and Kindle are replacing of all types printed materials. Today's babies will grow up to remember paper as something they enthusiastically smeared paint on with their fingers in pre-school and little else. Photography is managing to keep pace. Many photographers aren't.

Why are some photographers willing to change and others happy to stay as they are—even as the world changes?

≼ 76 ≽

Ignoring the manual is no longer manly.

It used to be that an owner's manual was discarded along with the box and styrofoam inserts that held a new camera. No longer. Today the manual should be read several times (as painful as that may be) and then put in your gear bag. Seriously. No matter how smart you are, no matter how much you use your gear, there will come a day when a mental hiccup blocks out that one technical step that gets you the shot you want. Today's DSLRs and speedlites have so many features that it's no longer manly (or smart) to ignore the manual.

How does your ego get in the way of
your becoming a better photographer?

Play photography as a team sport.

In many ways, photography is a team sport. Anytime you are shooting a subject who is breathing, there's an interplay through the lens between people. On more complicated shoots, there can be assistants, grips, gaffers, makeup artists, and stylists for hair, wardrobe, and props. You may have an art director or a client on set. It's important to understand that even though you may be the one pushing the shutter button, your photography will be the scorecard for how well any number of people are working together.

If a shoot is a team effort, are you ready to be the quarterback?

**Spend more time shooting than
you do cruising Web forums and blogs.**

It's easy to be in the world of photography without being a
photographer these days. While the Web has quickly made
huge amounts of information and insight available, it's im-
portant that you spend more time shooting than you do read-
ing forums and blogs. When it comes to honing your craft
and developing your vision, there is no substitute for a long
trail of decisions and mistakes that you made on your own.

Do you enjoy photography more for
the process, the images, or the socializing?

Photography from Tarzan's perspective

Many people romanticize the life of a photographer as if it was Tarzan swinging through the jungle from vine to vine. They see it as a glamorous and exciting life—full of momentum and confidence. Sure there may be moments when you want to agree, but then there's a vine that's just a bit too short or a tree that's in the wrong place. Suddenly the momentum of your career or your enthusiasm for your hobby comes to an abrupt halt. Every photographer goes through periods when he or she can't make a decent photo. Every photographer has periods that seem to move backwards rather than forwards. I'm sure that when Tarzan loses his momentum, he just climbs back to the top of a tall tree and grabs a new vine. No matter how dismal your photography may seem at the moment, don't give up on yourself. Jump off that safe limb and grab a vine. Sometimes saying "I can do this" is all it takes to get started again.

What can you do to restart your photography after a stall?

**The boldest creatives dance on the tightrope
when it has no safety net.**

Creativity flows best when it's unleashed without concern for outcome. Steering creativity away from potential failure simultaneously steers creativity away from potential success. Rather than be paralyzed by the fear of failure, the boldest creatives are energized by the opportunity to find a new way to succeed. A tightrope without a net could be seen as the potential cause of a lethal injury. Likewise, a tightrope without a net could be seen as an opportunity to dance like one has never danced before. The only difference is one's state of mind when stepping out onto the rope.

If letting go is critical to getting a good start,
why do you hold on so tightly?

**If you don't believe in yourself,
then don't expect others to believe in you.**

Your journey as a photographer will degrade periodically into
a vat of self-doubt. Often there will be no warning before
you find your emotions plunging into an abyss. As photog-
raphers, we wear our insides on the outside. Our best images
show the world what we think and how we feel. Rejection
can bash around our souls like a pinball at the arcade. One
over-zealous comment from an editor, one job not given by a
prospect, one errant comment from a spouse or dear friend,
and the emotional free fall starts. Sometimes your sense of
worth will be rescued by these same people. Sometimes it will
be up to you to rescue yourself. Either way, your sense of self-
worth always will be the barometer for others when it comes
to how much faith they should put in you. Your journey
back to the surface will often begin with the simple mantra,
I believe in myself. Say it again and again—even when you
don't. Eventually you will. And when you do, so will others.

Confidence, faith, self-esteem, praise, encouragement—
what do you need to do to keep your emotional tanks filled?

**Sometimes the best way to see something
is to not look straight at it.**

When we're *not* thinking about it, our vision is driven by intuition. Our eyes dance and flit around without a specific purpose. As photographers we are captured again and again by sights—captured initially without understanding the source of the magnetism that drew us in. When we truly see, what we experience is not what's in front of us, but rather our connection to what's in front of us. Conversely, when we look too hard, we often cannot see.

What limits your ability to see?

The enslavement of photography as a 2-D medium will one day be thought of as ancient history.

For millennia, we made pictures without understanding the principles of perspective. We expressed ourselves on cave walls, animal skins, cloth, and paper. Then the rise of the camera obscura during the Renaissance created an understanding of how to convert 3-D vision onto a 2-D surface. Our ability to decode sets of converging lines and the size of one object relative to another has served us well for the past 600 years or so. For the most part, photography followed this path. We are in the midst of a digital revolution that is replacing grains of silver and drops of ink with pixels of light, but photography largely remains a way of reducing our three-dimensional experiences into displays of tone and color spread across a flat surface. Even our brief forays into 3-D technology for the most part rely upon the visual merger of two images initially presented in 2-D. Looking forward—just as the Paleolithics who painted their enchanting pictures of horses and cows on cave walls had no concept that perspective and photography would ever be invented—I've no idea what the distant future of photography will look like. I am certain, however, that our never-ending search for more faithful and efficient ways of capturing and portraying the world around us will one day take us across a threshold that renders the era of 2-D photography as primitive as an aboriginal painting seems to us.

How would you describe a future of photography without referring to anything that currently exists?

**Get used to the idea of other people
running forward with your ideas.**

The thing I hate most about not getting a job that I've pitched hard is knowing that some other shooter will likely benefit from the ideas contained in my proposal. In hindsight, I often chide myself over ideas given away in good faith while pursuing a job that I really wanted to land. There's a delicate balance—one that's hard to see in the moment—between collaborating with a prospect during the pitch and not giving her enough insight into my creativity. Every time a noteworthy project slips beyond my grasp, I put myself under cross-examination about what I did and didn't say. Through the years, I've decided that my creativity is meant to be shared. Still, the urge to be bitter returns every time I see someone else running forward with a few of my ideas.

If bitterness holds you back, why are you holding onto it?

Embrace stress as the opposite of apathy.

A violinist once pointed out that tension is absolutely necessary for him to make beautiful music. If his bow is too tight, it will snap. If his bow is too loose, the strings will wail rather than sing. The key, he said, is to have the right amount of tension. Likewise, as a photographer, I'm always tense at the beginning of a shoot. Rather than get more stressed because I'm stressed, I've come to embrace the tension as a signal that I really care about what I'm doing. Consider your stress to be an indication that you really care about the outcome of your efforts. If you start an important shoot and don't feel some stress, then you really have something to worry about.

Besides stress, how else do you
know that you care about your work?

A camera is not a license to be a jerk.

Why is it that some photographers loose their sense of responsibility and compassion when they pick up a camera? How do bits of metal, plastic, and glass empower some shooters to discard their humanity and turn into overlords? After all, it's just a piece of machinery that they are holding. The opportunity to photograph others should stimulate a sense of service rather than an obsession to dominate. Now, don't get me wrong. When I'm making images, I feel a strong obligation to shepherd my subjects while they are in front of my lens. I won't hesitate to guide them and control the process. I'll pick wardrobe, guide makeup, and select props. I tell them my vision. I ask them to move this way or that. I direct where their eyes look. The difference is that I take charge for the benefit of the photos that will be produced and not out of a need to be authoritative. As the photographer, it's my responsibility to make the best images I can and to not waste the time of my subjects. Being a director is different from being a dictator. What I don't understand is why some guys (and they always seem to be guys) feel that holding a camera is a badge of authority and a license to be a jerk.

Are you willing to see yourself as a representative of all photographers?

Kodachrome is dead. Long live Kodachrome.

When Kodak announced that it was discontinuing the production of Kodachrome—the finely grained slide film used by generations of *National Geographic* photographers (and legions of us who aspired to be *Nat Geo* photographers), I was surprised. Kodak's announcement surprised me—not because I thought Kodachrome would be around forever—but because I thought it had died years ago. In my digital world, Kodachrome and all the other 'chromes became anachronisms when I shelved my film gear in favor of an electronic workflow. Upon hearing the recent news, I felt no guilt or loss over Kodachrome's demise. After all, I can get the look of Kodachrome in any number of Photoshop plug-ins. It used to be that you'd buy a particular film for the way it handled color. Now, you can drive to that same end by moving a few sliders on the computer monitor. Surprisingly, many photographers truly lamented Kodachrome's death as if part of their personas had passed on too. For me, it's a sad day when photographers identify more with their gear and supplies than they do with the images they create. Ultimately we have to ask if the image or the process matters most.

What gear, software, or supplies do you allow
to define who you are as a photographer?

**If you don't make a lot of photographs that
you didn't intend, then you're not working hard enough
or, maybe, you're working too hard.**

I'm not too proud to say that many of my best images are
ones I didn't intend to make. My hero shots are often images
that I came upon as I ventured down a visual path during
a shoot. It doesn't matter if I'm in the studio, on location,
or just rambling around—I'm often surprised by the photos
I find that weren't there a moment before. When I'm in a
good state of mind, I stumble over pictures again and again.
One visual thought leads to another and another. Coming
away with a lot of photographs that I didn't intend is a sign
that I'm open to inspiration. Coming away with just a few is
a sign that I'm either being lazy or much too wound up to
allow myself to truly see.

How do you recognize that you are off-balance?
What do you do to get back to center?

Look along the edges to find the in-between.

Without serenity as its opposite, chaos is not chaotic—it's normal. Likewise, light cannot be known in the absence of darkness, just as poverty cannot be understood in the absence of wealth. Contrast adds power to images. For dramatic light, seek not the storm. Rather, race to where it collides with the calm. For social commentary, show not the child in squalor. Rather, show the child in squalor that washes against the shore of prosperity. To create powerful images, look for the scenes in-between. As you wander, you'll not find contrast in the middle. Rather you'll find it along the edges.

Beyond light, what other types of contrast
do you capture in your photography?

The exotic is easy. The common is hard.

Many photographers travel great distances to better their craft. Upon returning home, their peers marvel at the spoils of the adventure—distinctive portraits, dramatic landscapes, and shots of intriguing food, flora, and fauna. The moment you point your lens at an exotic subject, the journey to creating an interesting photograph is half-finished. The second-half is often completed by technology rather than intention. If you really want to hone yourself as a photographer, then point your lens at the people, places, and things around you every day. When you can routinely craft an image that captures a new way of seeing the common, then you are truly growing as a photographer.

As a photographer, are you a trophy hunter or a prospector?

Allow yourself to be captured.

I had an image in my head and went into the desert to create it. I worked diligently for hours—directing my action with my vision. When I was done, I stood there—still and silent—among the Joshuas. Day had given way to night. As the spreading darkness took away my sight, I came to see that I had failed. My vision had been an expression of my intellect and not of the emotion of the desert. Rather than think more, I listened. The vastness of the desert silence began to capture me. The more I listened, the more I saw the desert anew. Under a tightly woven blanket of stars, I started to work again. Eventually I created the image that I unknowingly had come to the desert to create. It was not an expression of me. It was an expression of how I had been captured by the desert.

Are you invigorated or dismayed when you discover that your work falls short of your intentions?

Ignorance is relative.

"Everyone already knows this" is a knife that many photographers use to edit their work before it's created. Don't hold yourself back because you fear that you have nothing new to say. Remember that our individual journeys give each of us unique insights. No one knows everything. Even an educated man considers old ideas that he has not heard before as new. Your journey has value. Share it.

Are you willing to share your insights?
If not, what holds you back?

**Creativity mixes with safety about as well as
olive oil mixes with club soda.**

As a creative, your ideas will spawn efforts and your efforts will
generate new ideas. When your creativity is really humming
along, without warning you will eventually discover that
you are completely alone in territory that you don't rec-
ognize. You'll think, "This is garbage, no one will like (or
understand, or buy) this." Consider whether your self-doubt
is driven by the newness of the idea and the unfamiliarity of
the terrain. Set aside your fear and intimidation. Let go of
the side of the swimming pool. The frontier of creativity is
untamed and largely unknown. Eventually your frontier will
become everyone else's Main Street. By then, if you remain a
creative, you'll be racing out to new horizons that are equally
unknown.

When you experience self-doubt, is it better
to work through it or not worry about it?

Don't confuse distraction with creativity.

Creatives often think that they are working when actually they are just really distracted. Saying to yourself "Because I'm a creative, it's OK for me to [hang out on Twitter, watch a movie, play a video game, surf the web, *your favorite distraction here*]." Sure there are times when you need to take a break. Be honest about how you spend your time. Learn to tell the difference between procrastination and a creative recharge.

Are you honest about when you're procrastinating?
If not, what phrase can you use to tell yourself so?

There are many ways to cross the chasms.

The more you define your life by your photography, the more you'll encounter the chasms of self-doubt and lost enthusiasm. These are common emotions for shooters to go through at one time or another. Sometimes our chasms are wide but shallow. Other times, they may be deep but narrow. These are the easy chasms. The hard ones are both wide and deep. For the big ones, you have several options: back up and get a running start; build a bridge; or take the long way around. The important point to remember is that if you want to get across, you'll find a way.

Is there a difference between persistence and motivation?

Mistakes happen. Get used to starting over.

Mistakes happen and work disappears. Back in the film days, images were lost when the back of a camera was opened before the film was rolled back into the canister or the distraction of an engaging conversation in the darkroom lead to the bathing of film in fixer before the developer—resulting in a clear strip of acetate. Today, hard drives get corrupted or memory cards are reformatted before the files are safely copied elsewhere. Get used to the idea that work will be lost. Sometimes it will be your fault. Other times, it will be the oversight of another. Either way, get back to work. If you were creative enough to make a great image one time, you're creative enough to make another equally compelling image. Sure, it won't be the same image you made before. Sure, the scene or the moment may never happen again. You can quit—or you can move forward. It's your choice. Have a quick tantrum and get back to creating. You'll likely find that what you create the second time around is more interesting than your first pass.

How do you deal with mistakes—
those caused by you, those caused by others?

**Be prepared for your dreams to come true
(at least a few of them).**

Living as a photographer is a tough journey. It is far easier for others to ignore you or put you down than to celebrate your work. Your persistence, passion, and originality are a trident that you must carry—even when weary. If you hang on long enough, then your dreams (at least a few of them) will come true. Don't let the delay in their arrival cause you to dismiss their worth. Your dreams, your hopes, your aspirations all have value—because they are yours. Celebrate the arrival of each and every dream, no matter how long it takes for them to arrive. Then, use the celebration as a stepping stone to continue on with your journey as a photographer.

If a dream is an extremely long time in arriving, does this mean that its importance is less than when you first embraced it?

Join the LIDLIPS group on Flickr.

Discuss your thoughts about LIDLIPS.

Share your LIDLIPS-inspired photos.

flickr.com/groups/lidlips

Follow Syl On:

PIXSYLATED.COM
HONESTLY BIASED INSIGHTS

Also: Facebook and Twitter (syl_arena)

⚎ About Syl ⚎

SYL | 'sill'
1. short for 'Sylvester'
2. rhymes with 'Bill', 'Phil' and 'Will'
3. not pronounced 'Sile' or 'Sly'

Shortly after Neil Armstrong stepped onto the moon, Syl Arena "borrowed" his father's newfangled Polaroid camera, climbed a tree, and made his first photograph. Syl was in the third grade. He has wandered the world of photography ever since.

In college, Syl studied commercial photography at Brooks Institute and fine art photography at the University of Arizona (BFA, 1984). Among his more noteworthy accomplishments in school was the construction of a pinhole camera that used 20" x 24" litho film. True to his eclectic style, Syl then printed these giant negatives as cyanotypes, carbon prints, and screen prints—a early indication of Syl's willingness to explore the boundaries of photography.

Jumping ahead nearly three decades, Syl's blog, *PixSylated*, gained a global audience within a year of its launch. Beyond LIDLIPS, Syl has been recognized for his articles on PixSylated about color-critical workflow and tethered shooting as well as several articles in which he turned noon to night by firing off a dozen Speedlites together. (*PixSylated.com*)

As the founder and director of the Paso Robles Workshops, Syl is developing a boutique program in California's Central Coast wine district for the education of amateur and professional photographers. (*PasoRoblesWorkshops.com*)

As a commercial photographer, Syl photographs the people, lifestyles, and products of California's Central Coast for editorial and corporate clients. (*SylArena.com*)

Author Photo: *Anti-Gravity Hair*, self-portrait.

A Few of Syl's Favorite
Web Resources For Photographers

See *PixSylated.com* for
the unabridged Photo-Resources list.

A Photo Editor—*APhotoEditor.com*
An insider's view on the world of editorial photography, from Rob Haggart

Annenberg Space for Photography—*AnnenbergSpaceForPhotography.org*
An exciting new gallery and meeting place in the heart of Los Angeles

American Society of Media Photographers—*ASMP.org*
Great tutorials and resources for learning about the business side of working
as a professional photographer. Many local chapters across the country.

Cambridge In Colour—*CambridgeInColour.com*
A UK-based learning community for photographers—great tutorials

Center for Creative Photography—*CreativePhotography.org*
Home to the archives of more than 50 great 20th-century photographers

Chase Jarvis—*ChaseJarvis.com*
A voice on the leading edge of modern commercial photography

Chris Orwig's Flipside—*ChrisOrwig.com/Flipside*
Ideas, inspiration and images from the author of 'Visual Poetry'

DOUBLEtruck—*DTzine.com*
The most powerful photography magazine that you've never heard of

Illuminating Creativity—*JohnPaulCaponigro.com*
Valuable insights on creativity, vision, and technique from JP Caponigro

International Center for Photography—*ICP.org*
Legendary museum and school in the heart of Manhattan

Joe McNally's Blog—*JoeMcNally.com/blog*
Tips and tales from the Indiana Jones of editorial photography

Kelby Training—*KelbyTraining.com*
Online training for photographers and all other types of creatives

Light Stalkers—*LightStalkers.org*
Professional / social resource for journalists, filmmakers, photographers

The Luminous Landscape—*Luminous-Landscape.com*
Michael Reichmann's dynamic site—detailed reviews and insights

National Association of Photoshop Professionals—*PhotoshopUser.com*
Homebase of NAPP—the organizers of Photoshop World

Nice Photography Magazine—*NicePhotoMag.com*
Don't let the name fool you. This is a great blog on photography.

Photo District News—*PDNonline.com*
The best magazine for insights on professional photography in the U.S.

Photo Focus—*PhotoFocus.com*
One of the most prolific sources for information about photography

Photoshop Insider—*ScottKelby.com*
Scott Kelby (and friends) cover the world of digital photography

Picture Licensing Universal System—*UsePlus.com*
Spearheads the international movement to standardize photo licensing

Pixelated Image—*PixelatedImage.com*
International photographer David duChemin's energetic blog

Rob Galbraith Digital Photography Insights—*RobGalbraith.com*
Always one of the first to break the news in the photography world

Society for Photographic Education—*SPEnational.org*
Resources for photography teachers in all types of environments

Stock Artists Alliance—*StockArtistsAlliance.org*
The international alliance of stock photographers

Strobist—*Strobist.com*
David Hobby is ground zero for information on flash photography.

What The Duck—*WhatTheDuck.com*
The comic strip for photographers—seriously

Wilhelm Imaging Research—*Wilhelm-Research.com*
Henry Wilhelm is the final word when it comes to archival ratings.

Zack Arias—*Zarias.com*
Direct, passionate, informed—the energetic pro who started the
One Light movement

Shoot with Syl...

PASO ROBLES
WORKSHOPS

A boutique workshop program for photographers
in the heart of California's Central Coast wine region.

Conveniently located halfway between
Los Angeles and San Francisco.

1-day to 1-week workshops.

Great instructors.
Great setting.
Great food (and wine).

PasoRoblesWorkshops.com

CPSIA information can be obtained at www.ICGtesting.com
Printed in the USA
268540BV00005B/93/P